British Museum Objects in Focus

The Swimming Reindeer
Jill Cook

THE BRITISH MUSEUM PRESS

D1151385

First published in 2010 by
The British Museum Press
A division of The British Museum
Company Ltd
38 Russell Square
London WC1B 3QQ

www.britishmuseum.org

A catalogue record for this book is
available from the British Library

ISBN 978-0-7141-2821-4

Designed by Esterson Associates
Typeset in Miller and
Akzidenz-Grotesque
Printed and bound in Spain by
Grafos S.A.

Acknowledgements
My thanks are due to friends and
colleagues who have inspired,
encouraged and helped my work
with the reindeer. Among the many
I must particularly mention Neil
MacGregor, Jonathan Williams,
Janet Ambers, Clare Ward, Sue La
Niece and Nigel Meeks at the
British Museum, Adrian Lister at
the Natural History Museum, my
French colleagues and savants Jean
Clottes and Ann-Catherine Welté,
as well as the Bradshaw Foundation
and the late artist John Robinson,
each of whom has contributed
something particular to my
thinking. I am also extremely
grateful to Stephen Crummy,
who prepared the map and
the illustrations in Figs 10, 19,
20 and 29.

Mixed Sources
Product group from well-managed
forests and other controlled sources
www.fsc.org Cert no. SGS-COC-005160
© 1996 Forest Stewardship Council
FSC

Contents

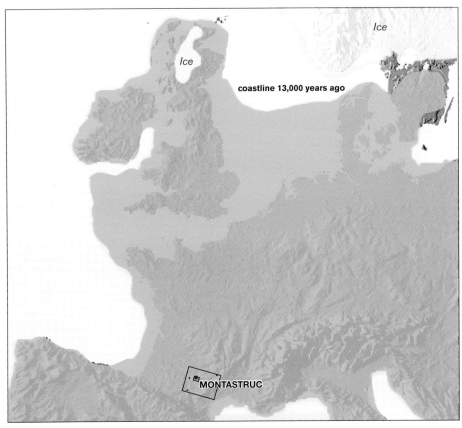

Ice

Ice

coastline 13,000 years ago

MONTASTRUC

Rodez

MONTASTRUC
Montauban

Toulouse

0 50km

Courbet

MONTASTRUC
Bruniquel

Penne

0 10km

Prologue

In 1887 the British Museum acquired a masterpiece of Ice Age art found some twenty-one years earlier at the site of Montastruc in the Midi-Pyrénées region of France. The sculpture, carved from mammoth ivory, consists of a pair of reindeer, a male following a female, and is known as the 'Swimming Reindeer' because the animals have their heads up, antlers tipped back and legs extended as if they are in water (Fig. 1). Their bodies are well proportioned and carved in the round to show their natural features in great detail. Found with tools, weapons, other works of art and animal bones, also now in the Museum's collection, the piece dates from the end of the last Ice Age and is at least 13,000 years old. Although only 22 cm long, the reindeer form the largest and most remarkable work on ivory known from this period. The sculpture is a masterpiece in a long tradition of figurative art that began in Europe after the arrival of anatomically modern humans about 38,000 years ago and lasted until about 10,000 years ago. This book takes a close look at the object as a work of art older than anything in the Museum's collections from Babylon, Greece or Egypt, and tells the story of its discovery and its historical and artistic significance to the world.

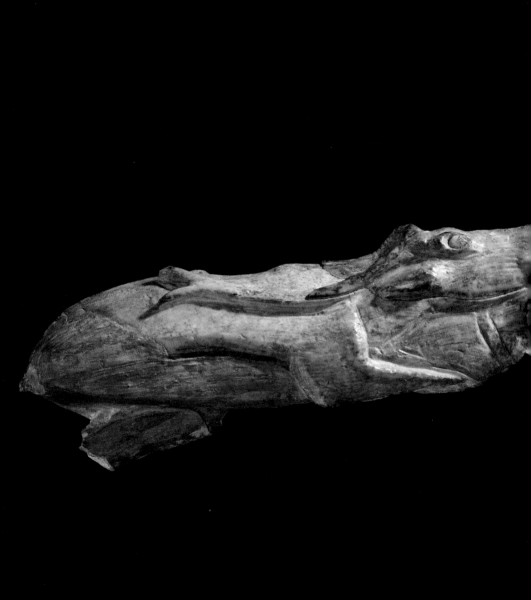

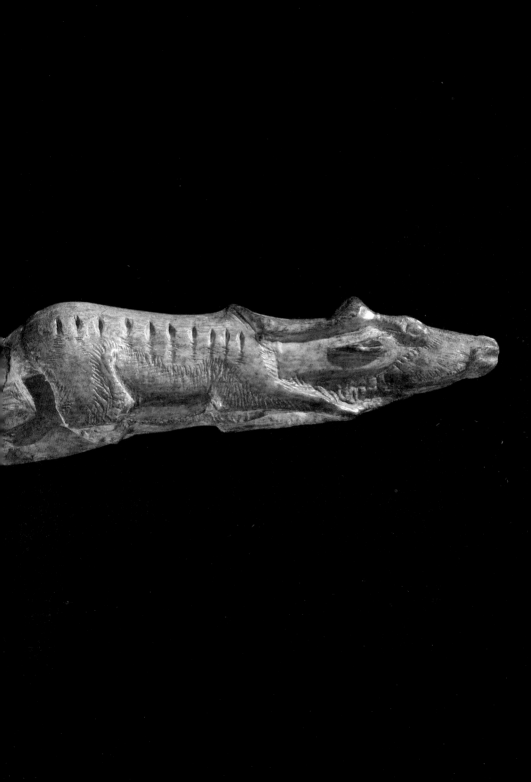

Chapter 1
Discovering Ice Age art

2 Romantic view of Montastruc rockshelter, drawn by Louis Figuier and published as an engraving in his book *Primitive Man* (1870).

European art enjoyed a renaissance during the final 5,000 years of the last Ice Age. The great friezes in the famous caves of Lascaux, Niaux, Pech Merle and Altamira were painted during this period and there was an extraordinary flourish in the decoration of objects, particularly in the Pyrenean region. The Swimming Reindeer is among the greatest of the many miniature or so-called 'portable' masterpieces found from this period, and one of just a few pieces produced as a sculpture rather than a three-dimensional carving to decorate a tool or weapon. The story of its discovery also brings to light the unveiling of a world of art unknown before the late nineteenth century.

A precious find at Montastruc

In the 1860s the French railway network was expanding rapidly. From the main Paris to Toulouse line, a spur was built to the north-east that would link Montauban and Rodez. For part of its length this line followed the left bank of the river Aveyron through a picturesque valley near the village of Bruniquel. Just downstream from there, the Orléans Railway Company purchased land for the tracks to run between the river and a steep limestone cliff called Montastruc Rock. Here, beneath the cliff overhang romanticized in a late nineteenth-century engraving (Fig. 2), an employee of the railway company, Peccadeau de l'Isle, found the Swimming Reindeer. The work was then in two separate pieces, and would not be recognized as forming a single sculpture until 1905.

We know very little about Peccadeau de l'Isle. Given his responsibilities for overseeing the construction of the railway, we may assume that he was a man with a reasonable level of education who, nonetheless, had to work for his living. In 1903 the archaeologist Emile Cartailhac described de l'Isle's work at Montastruc as 'thorough and very observant', but we can only guess at his motives for digging through a thickness of nearly seven metres of

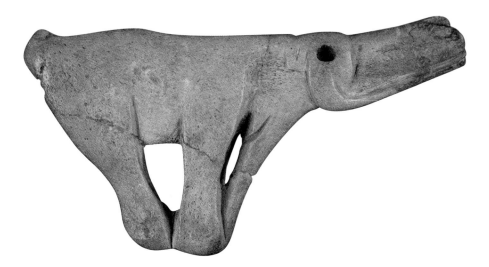

3 Part of a spear thrower carved from a reindeer antler in the shape of a mammoth. Found at Montastruc, Tarn-et-Garonne, central-southern France. About 13,000 years old, L. 12.4 cm. British Museum

partially cemented sands, silts and gravels beneath the 29-metre-high cliff. He certainly found some precious things. Apart from the reindeer, he also recovered the first known three-dimensional carving of a mammoth made from reindeer antler (Fig. 3), as well as numerous drawings engraved on bone, antler and stone slabs, tools, hunting and fishing equipment and animal bones. He presented a paper on these discoveries to the French Academy of Sciences in Paris in March 1867, and later that same year brought them to the notice of an even wider public by exhibiting the reindeer and the mammoth at the great Exposition Universelle alongside finds from other recently discovered European sites.

Had de l'Isle's motive been financial gain, this would have been the time to sell his finds, given the interest they generated among the international public and academics visiting the Paris exhibition, but, although he never excavated or published anything else, de l'Isle kept the material until the 1880s. Then, in 1884, he showed it in a geographical exhibition in Toulouse. Perhaps he hoped that it would be purchased by the Muséum d'histoire naturelle in that city, but the curator, Emile Cartailhac, whose own fame as an archaeologist was growing, made no attempt to acquire it. So in 1887 de l'Isle offered his collection to the

British Museum for 150,000 francs, approximately equivalent to £580,000 today.

Augustus Franks, the keeper responsible for the north European archaeological collections at that time, had seen the reindeer in Paris but declined de l'Isle's selling price because it exceeded the Museum's entire annual acquisition budget. Nevertheless, he sent his assistant Charles Read to see the material in Toulouse. Read negotiated and bought the collection for £500, equivalent to about £30,000 today and half the price of the collection from Courbet Cave, a site just upstream from Montastruc, where engraved drawings of animals on bone had been excavated in 1864.

Appropriately, Franks purchased the Montastruc collection with funds bequeathed by Henry Christy, a Victorian entrepreneur who used his fortune made in industry to excavate caves in south-west France. Christy's discoveries in collaboration with the great French palaeontologist Edouard Lartet in 1864–5 had proved beyond doubt that, at a time when it was much colder, people had coexisted with mammoths and other animals now extinct in Western Europe, such as reindeer, saïga antelope, musk ox and bison.

Peccadeau de l'Isle's place in history

Today it is the great painted caves of Altamira in Spain and Niaux, Lascaux, Pech Merle and Chauvet in France that dominate our ideas of Ice Age art, but none of these sites was known when the Swimming Reindeer were unearthed at Montastruc. The first painted cave to be discovered was at Altamira, near Santander, in 1880. Inspired by seeing artworks such as the reindeer in France, the owner of the Altamira site, Marcelino de Sautuola, started to excavate at the entrance to the cave in the hope of finding similar pieces. His daughter, Maria, wandered further in and saw a fresco of bulls painted on the ceiling of an inner chamber. De Sautuola published the discovery but the paintings were regarded as fakes because they were so fresh and modern in appearance. Gradually other painted sites were found but it was not until 1904 that his detractors admitted they had been wrong and accepted the antiquity of sites with painted and engraved pictures on the walls.

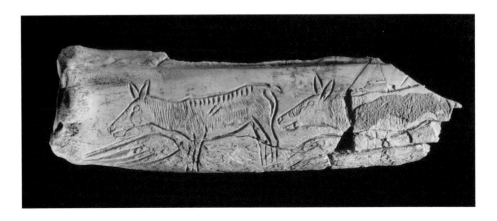

4 Drawing of two deer, incised on bone. Found in Chaffaud Cave, near Vienne, central-western France. Probably about 13,000 years old, L. 13.2 cm. Musée d'Archéologie Nationale, Paris

There was never such doubt about drawings or carvings on bone, antler, ivory or small stone slabs, although the first recorded discovery was puzzling. In 1833 or 1834 a solicitor called André Brouillet found an engraved drawing of two female deer on a piece of reindeer bone in Chaffaud Cave, on his land in the hills between Poitiers and Angoûleme (Fig. 4). Brouillet supposed the piece must have been made by the Celts, then thought to be the oldest pre-Roman inhabitants of France. His conclusion was not surprising at a time when the great age of the earth was generally accepted but the length of human antiquity was still considered to be no longer than 6,000 years, as calculated back through classical history and the Bible. This was to change with the recognition of the contemporaneity of stone tools and extinct animals found in gravels of the river Somme.

Stone tools and human antiquity

By the 1850s many discoveries of stone tools with the remains of extinct animals had been published, but geologists were often sceptical about them. Excavation techniques were rough and, without carefully recorded observations, the geologists were often right to suggest that tools and bones of quite different ages had come to be associated by natural processes. However, the publication of Charles Darwin's *On the Origins of the Species* in 1858 offered a new view of humans as part of nature and subject

to evolution over a long period of time. In April 1858 a group of leading British geologists and archaeologists visited the Somme to see the sites and finds that the French geologist Boucher de Perthes had been working on since 1828. Although Perthes had recognized the significance of his finds, his ideas had not found general acceptance because the highly respected palaeontologist Baron Cuvier had stated categorically that '*l'homme fossile n'existe pas*' ('fossil humans do not exist'). Few were willing to speak in support of evidence undermining the ideas of such an eminent zoologist, who dominated the Academy of Sciences in Paris, but the meeting on the Somme undid this knot and endorsed Perthes's findings. Fossil humans must exist. Now the race was on to find human fossils, and to discover what the earliest people were like and when and how they lived.

Art takes a part
Having participated in the proving of Perthes's discoveries, Edouard Lartet realized he could find more evidence of ancient human activity and teamed up with Henry Christy, whom he had met at Abbeville. Together they excavated several important cave sites in the Dordogne, and in 1864 discovered an engraved drawing of a mammoth on a large piece of tusk at La Madeleine (Fig. 5). This was positive proof that people had not just found and used fossil ivory but had certainly lived among the mammoths. In the same year Richard Owen, the eminent palaeontologist and

5 Drawing of a mammoth incised on ivory, found at La Madeleine, Dordogne, south-west France. Probably about 13,000 years old, L. 24.5 cm. Musée d'Archéologie Nationale, Paris. Engraving published in E. Lartet and H. Christy, *Reliquiae Aquitanicae* (1875), as fig. 2.

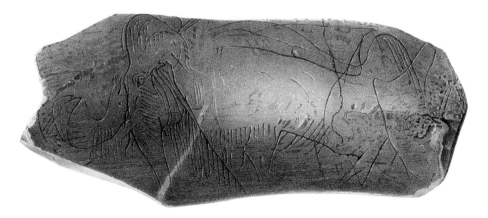

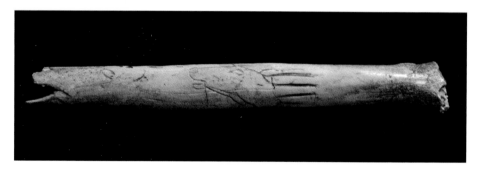

6 Drawing of a reindeer head, incised on bird bone. Found in Courbet Cave, Penne-Tarn, central-southern France. About 13,000 years old, L. 9.1 cm. British Museum

Superintendent of Natural History Collections at the British Museum, added to the evidence with a drawing of a reindeer head engraved on a bird bone (Fig. 6), which he excavated in Courbet Cave near Bruniquel, acquired for the Museum and published at the Royal Society in London.

It was in this competitive atmosphere of ardent new proponents of evolution and the greater length of human antiquity that Peccadeau de l'Isle excavated at Montastruc. His finds had a significant impact and the world marvelled at the quality of the ancient carvings, envisaging the reindeer as exquisitely elaborate dagger handles but not yet recognizing a fine sculpture. This was to come in 1905 when the abbé Henri Breuil, already well known as an accomplished archaeologist, visited the British Museum and, on examining the reindeer, realized that they were not two separate works but joined together to form what is still the largest and finest known ivory sculpture of the late Ice Age.

Such works are now known to be exceptional at this time. In the long period from about 38,000 to 21,000 years ago, sculpted figurines of humans and animals made of mammoth ivory are well known from many sites right across Europe, as far as Siberia. Then a major cold period, the Last Glacial Maximum, seems to have reduced artistic activity until about 15,000 years ago. At that time the painting of caves, the decoration of tools and weapons and the production of small sculptural works re-established itself in a quite different style. A closer look at the Swimming Reindeer helps us to appreciate the art of this period.

Chapter 2
Setting a natural scene

It is immediately obvious that this sculpture depicts two deer. As the sex of each animal is explicitly shown, it is also evident that the larger male (stag) is behind the smaller female (hind). Both animals have antlers. The only female deer which have antlers are reindeer, and this identification of the sculpted animals is confirmed by the distinctive facial features and the markings shown on the female's coat. She is almost 10 cm long and 3 cm high at the back. The larger figure has male genitals and its coat is not shaded, perhaps because mature males show less variation in their body colouring. His incomplete body is almost 11 cm long and 4 cm high. Both figures have a maximum width of 2.5 cm.

Looking at the underside of the animals it is easy to appreciate a sense of movement in the piece, although it is not quite complete (Fig. 11). The necks and legs of both animals are stretched out, suggesting they are in motion. The front legs of the female extend forward together, as do those of the male. The back legs of the female extend out behind her, but ancient damage to the back of the male raises questions about the original appearance of this end of the sculpture.

When first found, the rear left leg of the male extended back behind the animal, as shown in an early engraving of the piece (Fig. 9) and a plaster replica made in 1867. Unfortunately, this fragile back limb was broken off the original and lost some time before the abbé Breuil published his drawing of the piece in 1905. The area of the male's right hip and leg is damaged by ancient breaks, but it seems probable that it was treated in the same way as the left so that both back legs were carved extending out behind the animal, just like those of the female (see Fig. 11). Consideration of the replica also suggests that a short, stumpy tail would have been carved in the round, continuing the curve of the back down over the rump.

Reconstruction of the back of the male restores the symmetry and fluency commensurate with the composition as

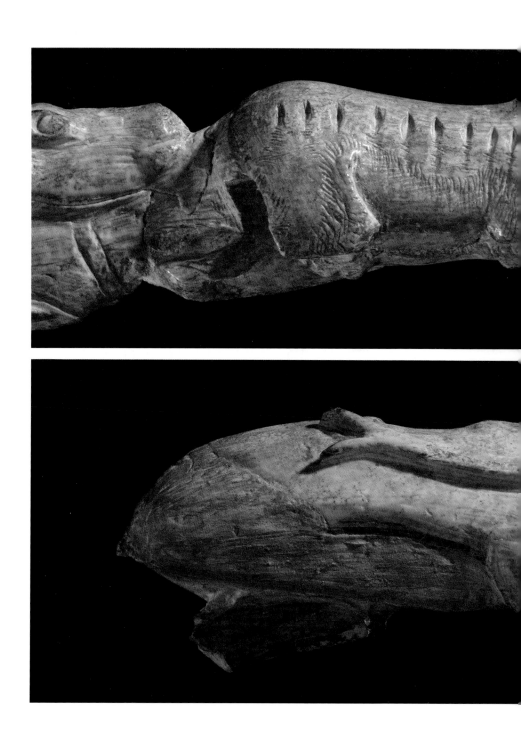

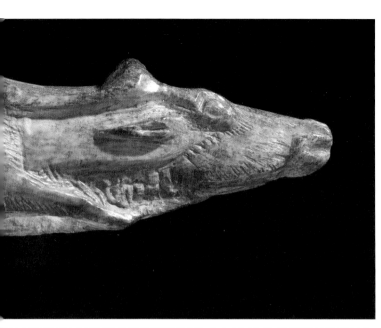

7 The Swimming Reindeer, detail of the female reindeer.

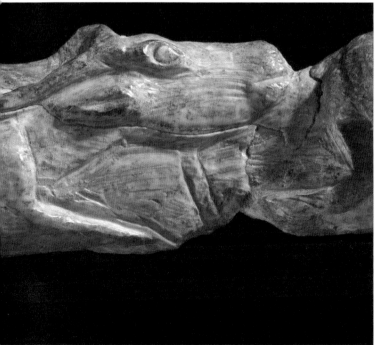

8 The Swimming Reindeer, detail of the male reindeer.

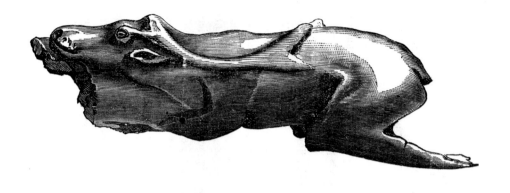

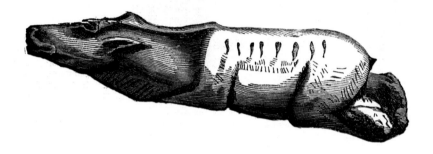

a whole (Fig. 10). This is difficult to appreciate on the
original because in the 1970s it was essential to repair the
area with a filler to prevent further deterioration of the
ivory. The featureless oval shape at the back now detracts
slightly from, but has preserved, the original achievement
of the artist.

The view from above

Looking at the sculpture from above, it is easy to
understand how it has come to be known as the Swimming
Reindeer (Fig. 12). The piece is narrow and conveys a
streamlined sense of movement. The heads are up, giving a
sleek, continuous line from nose to tail, and the antlers are
laid back along the bodies to accentuate this effect. This is
how the reindeer would have looked to a hunter observing
them in the river from the top of Montastruc Rock.

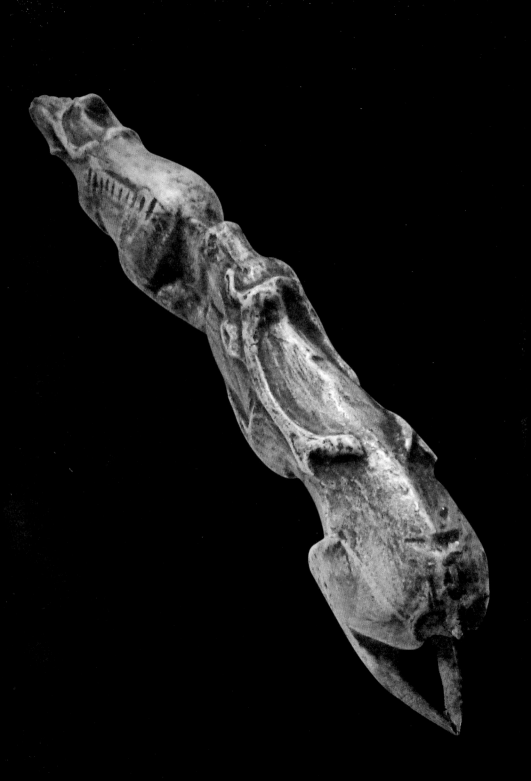

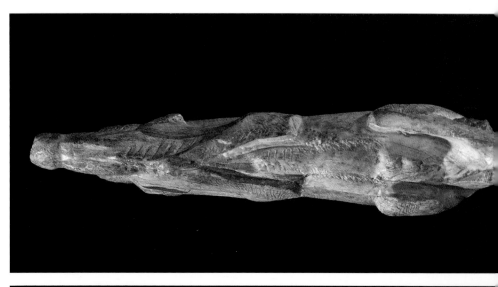

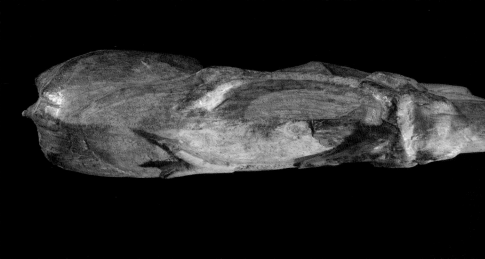

11 *top* The underside of
the Swimming Reindeer.
The ribs of the female
(left) are shown by
incised lines, the
nipples carved in relief.

12 *above* The Swimming
Reindeer from above.

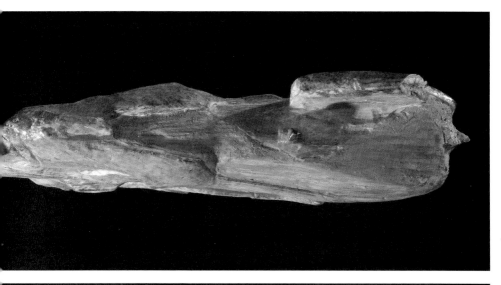

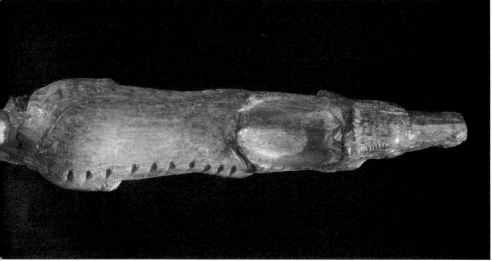

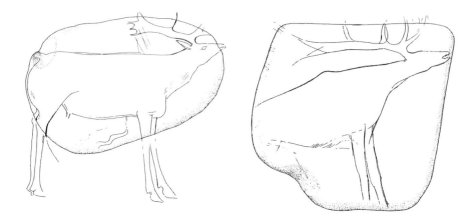

13 Drawings of reindeer incised on limestone slabs, found at Montastruc. About 13,000 years old, L. 10.8 cm (left), L. 13.7 cm (right). British Museum

The antlers of the female are appropriately short and contrast with those of the male, which are about two thirds of his body length. At first sight this may seem exaggerated, but such lengths are actually typical in real life. Nevertheless, the artist has departed from nature by omitting the forward extension of the antlers over the brow of the face, as may be seen in living animals (Fig. 16) or on drawings incised on slabs of limestone found at Montastruc (Fig. 13). With the animals in this position, this part of the rack would have stood up from the head but, given the shape of the ivory, the artist had to adapt their form to that of the material.

Modern hunters often value the impressiveness of the male reindeer they kill by the number of side branches (tines) present on each antler. On a mature animal these may number up to ten, whereas the antlers on the sculpture branch only at the top because of the perspective of the piece and the form of the material, although the beam length is undoubtedly that of an impressive stag. Despite this bit of artistic licence, the depiction of the cylindrical form of the antler beams is otherwise so accurate that it is possible to identify them as tundra reindeer. Known by the Latin name *Rangifer tarandus tarandus*, this sub-species is distinct from the Eurasian forest reindeer and the North American caribou, both of which have flattened antler beams and tines.

Heads and tails

The heads of the reindeer have their chins held up. Their noses are carved in relief with engraved nostrils, and the ears and eyes are similarly treated. The eye sockets are formed in relief and then the eyes added as engraved ovals, reproducing the goggle-eyed appearance of these rather poor-sighted creatures. The ears are folded back horizontal to the heads. On the female, engraved shading distinguishes the areas of darker and lighter colouring on the face. The space between the top of her legs and her neck is filled on both sides with slightly oblique, incised vertical lines which represent the skin flap that extends from the throat to the chest on living animals.

The face and neck of the stag are treated differently. Instead of fine shading there are quite deep, horizontal incised lines on both (Fig. 14). On the face this may be because the male does not have such distinctive colour marking, but their presence on the neck as well makes one wonder whether the artist intended these lines to indicate the slipstream of the water. It is impossible to validate such a suggestion, but similar lines do occur around fish heads and behind the reindeer head found nearby at Courbet Cave, about five hundred metres upstream from

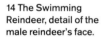

14 The Swimming Reindeer, detail of the male reindeer's face.

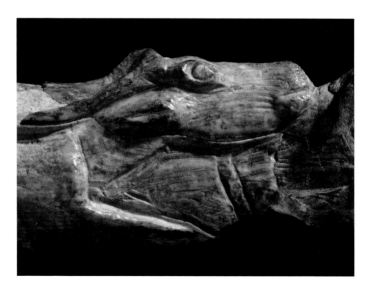

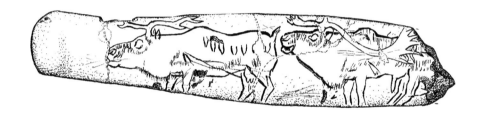

Montastruc (see Fig. 6). Equally difficult to interpret is the
open vertical oval shape formed by two ()-shaped lines
below the jaw line on the right side. This is not part of the
reindeer's anatomy and may represent a fish. A similar
shape may have existed on the left side but ancient damage
has obliterated the surface in this area.

The tails of both animals are obscured by ancient damage
but, whereas the end of the hind's back is smooth, the
replica shows a group of incised lines just above the base of
the tail on the male and the 1867 engraving (Fig. 9) suggests
that the short, stumpy tail was carved in the round.

Depicting the time of year

To those who know about reindeer, the artist communicates
a particular time of year. Mature male reindeer shed their
antlers in December, after the mating season, which lasts
from September to November, whereas younger males
(bucks) lose them in early spring. Hinds shed their antlers
in spring and regrow them over the summer so that they
can compete for scarce winter food supplies. All reindeer
moult in late spring, with tangled, matted hair hanging off
their coats, giving them a shabby appearance. Through the
summer they have short, dull coats, which by autumn grow
long and thick with distinctive yellowish-brown to white
markings. Both animals depicted on the sculpture have
antlers, and the shading of the female's coat suggests long
hair with distinctive markings and bands of colour, making
it evident that the artist intended to represent an autumnal
scene. The positioning of the male behind the female, as
well as the clear depiction of his genitals, may suggest
mating, which also takes place in autumn. A similar pairing

is drawn on a piece of antler found in the cave of La Vache at Ariège, about a hundred miles south of Montastruc (Fig. 15). Autumn is also a time when reindeer move to new pastures, swimming easily across lakes and rivers where they become particularly vulnerable to hunters (Fig. 16).

This clear indication of season is also seen in drawings incised on stone found at Montastruc. Pieces such as those illustrated in Fig. 13 show stags with large antlers, their heads up as if they are bellowing. Such behaviour is particularly associated with the mating season. However, this does not depict the time of year at which the site was occupied. Bernard Bétirac, who excavated at Montastruc in the early 1950s, found reindeer antlers which had been shed naturally and collected, rather than chopped from the skulls of dead animals. Furthermore, most of the bones are those of young animals, suggesting occupation during late spring into summer. This might mean that the composition also reflects an imagined scene from the past or in the future that could relate as much to a human activity, such as moving camp in autumn or a winter ceremony, as to animal behaviour.

Comparisons

While the drawing from La Vache depicts a similar scene of a reindeer pairing, no other sculptures of reindeer are known. Furthermore, the reindeer are the only work of art on ivory from Montastruc and other types of ivory object are also lacking. This may reflect a dwindling resource. Mammoth numbers declined in Western Europe after the Last Glacial Maximum and they were gradually becoming extinct as the climate warmed and hunters predated on decreasing numbers of increasingly stressed animals. Just upstream from Montastruc, the people who used Courbet Cave made extraordinarily fine, needle-like points for darts from ivory and little beads in the form of female figures viewed in profile. This type of female figure is seen sculpted in ivory either in bead or figurine form at sites such as Fontalès, further upstream in the Aveyron valley, and further afield at Petersfeld in south-west Germany, but their flattened outline shapes are much more two-dimensional

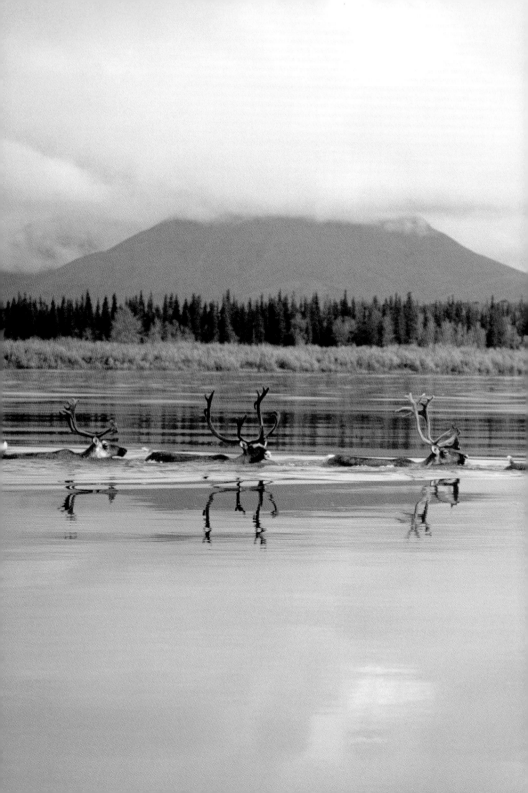

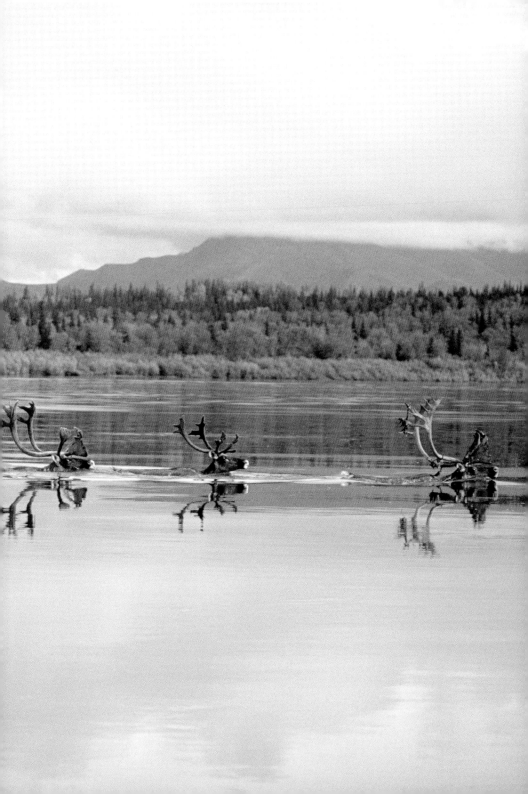

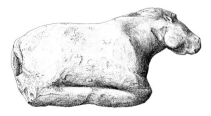

17 *above, left* Drawing of a horse head carved in ivory, found in Duruthy Rockshelter, Landes, France. About 13,000 years old, L. 5.6 cm. Musée archéologique d'Arthous

18 *above, right* Drawing of a sculpture of a seated horse carved in sandstone, also found in Duruthy Rockshelter, Landes, France. About 13,000 years old, L. 26 cm. Musée archéologique d'Arthous

and abstract in form than the reindeer, dissimilar in both style and workmanship.

More closely comparable in form are an ivory horse from Espélugues, just outside Lourdes in the High Pyrenees, some eighty-five miles south-west of Toulouse (see Fig. 25), and an ivory horse head from the more distant site of Duruthy, Landes, about 125 miles west of Toulouse. The incomplete head from Duruthy is carved across the ivory to achieve a representation of the head's contours in a style that is realistic but also somewhat angular (Fig. 17). Only the mane is emphasized with engraved lines and, unlike the Swimming Reindeer, the facial features are carved but not emphasized by engraving. This is also true of a sculpted horse head pendant and a sitting horse from Duruthy, made of bone and sandstone (Fig. 18). These sculptures are close in form to the Montastruc reindeer, but the latter is distinguished by the use of incised shading. In this respect the Espélugues horse, carved out in the round with its features and coat emphasized by finely incised lines, is much more similar and, while both sculptures are unique, this shading seems to link them in style and technique to carvings on weapons, as well as drawings found at sites on the north-east side of the Pyrenees around Foix, about forty miles south of Toulouse. This comparison calls for a closer look at the style and techniques of working the reindeer.

Chapter 3
How the artist worked

19 The shape of the Swimming Reindeer in relation to the piece of mammoth ivory.

Selecting the material

The reindeer are made from the tip of a mammoth tusk, the curvature of which can still be observed in the outline of the sculpture. The artist carved the backs of the animals from the lower, convex edge of the tusk (Fig. 19). Although the narrowness of the figures might suggest that it was made on a longitudinal segment cut from a thick piece of ivory, the corresponding concavity of the lower outline suggests the tapering form of the tip of a tusk. Selecting this part of the tusk meant that the sculptor did not have to remove much material to create the animals, but it is impossible to say whether the shape of the raw material suggested the composition or whether the selection of the material was determined by artistic design.

The length around the finished piece implies that the original circumference of the tusk was approximately 12 cm and suggests that the ivory probably came from a young or female mammoth. The carving has removed any trace of how the hunter detached the segment but it is possible that

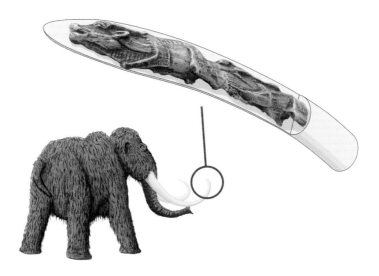

this was done using techniques observed on ivory found on Central and Eastern European sites. This involves incising a deep, broad groove around the circumference using a stone tool, and then chopping into the incision with a stone chopper, examples of which have been found at Montastruc. If the ivory is fresh it may then break cleanly across the diameter at this stage, whereas old ivory that has been exposed to the weather tends to split and crack. As early photographs and replicas of the reindeer show no evidence of splitting, it is probable that the artist selected a fresh tusk. An alternative method would be to loop a fibre cord into the grooved circumference and saw it apart.

Shaping the figures

The artist carved out the contours of the reindeer's bodies using stone tools. This involved the use of flint blades as knives and engraving tools called burins. Burins have a narrow working edge 2 to 5 mm wide, made at right angles to the edge of the flake or blade. Held between the index finger and thumb like a pencil or craft knife, they can be used at varying angles using all or part of the working edge to produce incised lines of different widths and qualities (Fig. 20).

Examining the reindeer under a digital imaging binocular light microscope reveals tool marks. These indicate that, having shaped the outline of the back and sides of the animals with a knife, the detailed contours of the heads, legs and antlers were emphasized with a burin. The lines are confident and most are achieved in one deliberate movement. There are no overlaps where the angle or curve of a line has been corrected or extended by second or third attempts. In this, the artist has left us visual evidence of great skill in reproducing details and proportions with extraordinary accuracy and precision.

The question of polish and colour

The surface of the reindeer is smooth and shiny, and raises the question of whether this polished patina is original, whether it was produced during burial in the sandy deposits frequently inundated by river floods at Montastruc, or if it

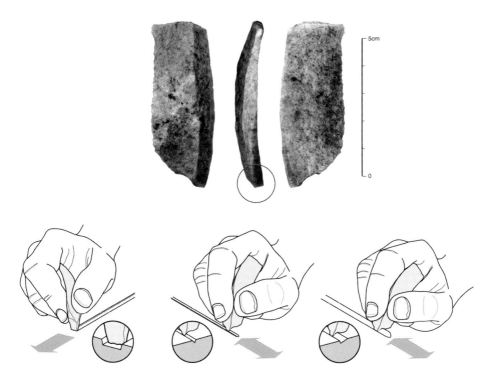

20 Flint burin used to produce various forms of engraved lines.

could be the result of handling since discovery. The answer to this question may be related to traces of colour on the animals.

Photographs of the Swimming Reindeer frequently give it a pinkish colour, which is misleading because it results from the way in which light sometimes reflects off the slightly translucent, off-white surface of the ivory. The black flecks are particles of manganese that come from the sediments in which the object was found. Looking past these features, the microscope reveals that the tool marks left by the shaping of the animals are slightly polished out. On its own this would be consistent with either a natural or handling polish, but the engraved lines depicting the details of the heads and bodies actually cut into the polished surface. This implies that, after shaping, the basic form was polished before the engraving of the details.

A polish could be achieved by a fine buffing agent applied with a little water and a piece of soft leather. Tiny red flecks

observed on the surface were investigated using Raman spectroscopy in the British Museum's Department of Conservation and Scientific Research. The Raman directs a laser beam on to minute traces of material, then detects energy wavelengths scattered by the beam (Fig. 21). The red specks on the reindeer produced a wavelength consistent with haematite, an iron oxide often called red ochre.

Ochre is often used for colour in Ice Age art, either in crayon form or powdered and mixed with water to make paint. It also forms a soft abrasive now called 'jeweller's rouge' and, as such, might have been used to polish and colour the contours of the reindeer. However, the specks of ochre could have come from the deposits in which the reindeer were found, in which case the buffing agent would have been very fine sand.

Adding detail

After carving out and polishing the shape of the animals, fine engraved lines were added to define their details. This was done using a flint burin and shows just how much variation in line width, depth and shape could be achieved by varying the angle at which the tool was held and the part of the edge used (Fig. 20). There is more engraving on the female than the male, but this does not necessarily mean that the female was more important or that the work was unfinished. Male

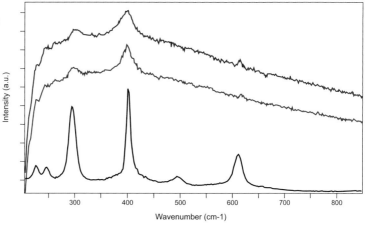

21 Graph showing the results of Raman spectroscopy. The red wavelengths produced by specks on the reindeer match the black index wavelength for haematite.

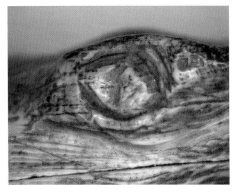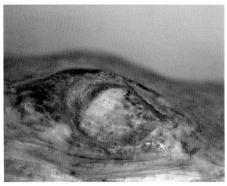

22 Details of the Swimming Reindeer; the male reindeer's left eye (left) and right eye (right).

reindeer have more uniformly coloured coats. Their light brown faces and bodies contrast with a white neck. The female coat shows more colour variation (see Fig. 23) and it is this that is represented in the engraved lines.

The eyes

After shaping the raised orbits around the eyes, the artist added engraved ovals to represent the eyelids. On both animals the eyes are given the perspective of staring forward, but this is achieved by a different technique on each eye. This is most clearly visible on the male (Fig. 22). His left eye is formed by several strokes from left to right, the upper lid being deeper and more convex. The same effect has been achieved on the lower lid by merging a group of lines on the left into a thinner single curve to the right. The pupil is represented by a zigzag.

By contrast, the right eye is formed by a single line that starts on the right, becomes wider and deeper on the left to give perspective, then curves and thins to the right. It has no indication of a pupil. The same sort of variation is present in the female's eyes. However, while such detail seen through the microscope lens provides insight into how the artist worked on a line by line basis, it is unnoticeable when the sculpture is viewed normally. If the detail means anything at all, it surely shows that the artist was working with the overall perspective of the composition in mind, rather than repeating actions that might have resulted in a rather more naive effect.

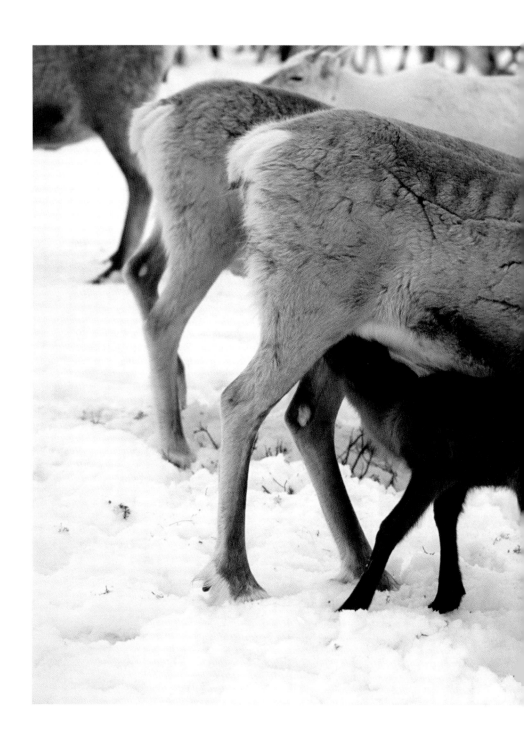

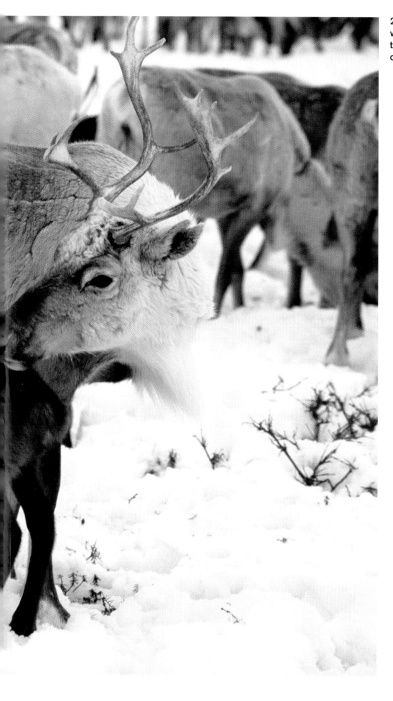

23 A female reindeer with her calf, showing the distinctive colouring of her face and coat.

The faces and necks

As noted, the female's face is delicately engraved to show its colour variation (Fig. 24). A series of oblique lines curve round below the right eye, becoming gradually shorter as they bend away from the nose. Smaller, obliquely incised lines form an oval behind the mouth and emphasize the line of the lower jaw. All these little incisions are made from top left to bottom right. There is less shading on the left side of the face but, below the throat on both sides, widely spaced obliquely incised lines slope forward and down a line from the underside of the neck to the chest. These indicate the long hairs of the skin flap (dewlap) characteristic of reindeer.

The face of the male has been treated differently, perhaps because of its more uniform colour. The visible lines are not traces of scraping that have not been polished out, but are deliberately and individually incised (see Figs 1 and 31). On the cheeks these horizontal lines bow upwards slightly, and below the jaw they curve downwards, giving an impression of motion or, as previously suggested, water.

The female body

Close up, the engraving on the opposite sides of the female's body can be seen to vary, just as the incisions shading her facial features differ on the left and the right. Whether this variation was caused by the maker being left- or right-handed, engraving at different times or by different artists, it does not detract from the overall effect and is almost unnoticeable except to the curious observer.

Images of the shading show a variety of techniques that could be achieved by using different parts of the burin edge at various angles and pressures (see Fig. 20). There are straight, obliquely incised lines; herringbone arrangements of short incised lines; fine, curvy vertical lines to indicate longer hair; cross-hatching or patches of deeper, interlocking oblique lines to emphasize parts of the heavier musculature at the tops of the legs; and fine, tiny incisions to indicate the edges of the white underbelly. Although the shading is not exactly the same on both sides of the body, it does form a sinuous band that reiterates the outstretched form of the reindeer and adds to the sense of movement, as

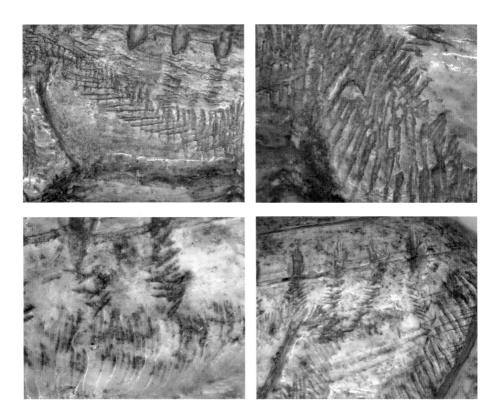

24 Photomicrographs showing various shading techniques.

well as outlining the contour of the animal's stomach and variations in coat colour.

Above this shading on both sides are ten deep, vertical, oval incisions that extend from the shoulders, along the flanks and over the hips. From the bottom of each oval there is a trail of tiny, horizontal to slightly oblique incisions made alternately from left to right and right to left. These extend to the line of the hair shading and were made after it (Fig. 24). Some female reindeer have a pattern of light and dark vertical bars in the darker area of their upper body coat (see Fig. 23), which may have been more prominent on Pyrenean reindeer as they are often marked in representations of reindeer from that region (Fig. 15). The ovals may represent these marks, but if this is the case, their number, depth and extension appear unnatural and the trails shown beneath them lack a natural explanation.

The top of the female's head and body is smooth and has no shading. Tool marks made by scraping from right to left can be observed with a lens. Her tail is not shown. By contrast, the underside of her body is carefully observed (see Fig. 11). Between the extended front legs, incised lines on either side of the contoured chest area indicate the ribs. Behind this, curving outwards on each side of the stomach, are rows of tiny, obliquely incised lines marking the edges of her white underbelly. Towards the rear, these lines curve in towards the teats, which are carved in relief.

Are the details significant?

From a curved piece of ivory the artist has carved a pair of reindeer. The details of the engraving reinforce the naturalism of the work evident at first impression. As a hunter and butcher the artist had detailed knowledge of the appearance and anatomy of the reindeer, and then reproduced them in the round. This in itself requires some complex mental processing of visual information because the animals are never seen all round at once and could only be viewed in profile, from above or below, front or back. Similarly, we cannot see all round the sculpture at once, so the variations in how the details are represented on the right and left sides do not distract us when viewing the work. In our mind's eye we process out the variations until they are pointed out.

The artist simply had no way of transferring a mirror image of the engraving from one side of the female reindeer to the other except by eyeballing it to convey the desired effect. This has worked because in this little masterpiece we recognize the naturalism of the animals, the accuracy of the perspective and proportions, as well as the elegance of a composition that encapsulates movement. The dissymmetry of engraved lines does not distract from this. What we do not know is whether the latter was actually important to those who saw the sculpture when it was made.

Comparisons

The work most closely comparable in form and shading to the Swimming Reindeer is the ivory horse found at

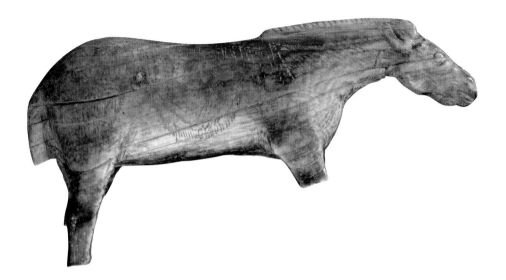

25 Sculpture of a horse, carved in mammoth ivory. Found in Espélugues Cave, near Lourdes, Hautes-Pyrenées, France. About 13,000 years old, L. 7.3 cm. Musée d'Archeologie Nationale, Paris

Espélugues (Fig. 25). The horse also appears to have been carved and polished before the shading was incised. The shading of the face, the curved band of incisions highlighting the contour of the stomach and the emphasis on the hind quarters are also reminiscent of the reindeer. However, the incised lines on the horse are short vertical dashes, quite different in style from those on the reindeer, whose shading bears a closer resemblance to that seen in drawings on bone and antler from the site of La Vache. To assess the validity of such comparisons and discover the milieu which inspired the reindeer, it is first necessary to consider when the piece was made.

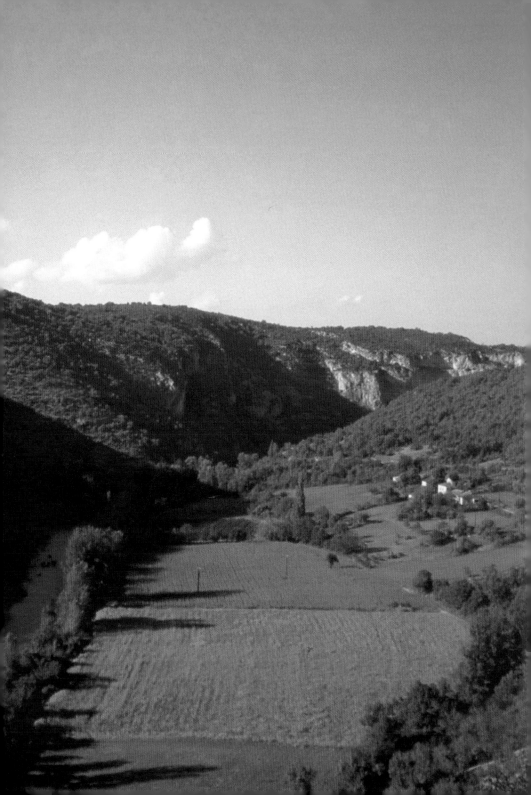

Chapter 4
The world of the artist

Dating the Swimming Reindeer

Nowadays we can say that the sculpture of the Swimming Reindeer is at least 13,000 years old. This estimate is based on geological and archaeological methods of dating, as well as two radiocarbon dates from other objects found on the same site. As we shall see, we already think this age is a bit young, but it would certainly have surprised Peccadeau de l'Isle and his contemporaries, for whom dating things made before written history and calendars was a new problem.

In describing their 1864–5 excavations in caves and rockshelters in the Dordogne, Edouard Lartet and Henry Christy noted that the sites contained similar tools made of stone, bone and antler, as well as a predominance of reindeer bones among the food remains. This suggested that they all belonged to the period of time then referred to as the Reindeer Age (*l'âge du renne*). De l'Isle realized that his finds at Montastruc were comparable to those of Lartet and Christy and he placed them in the same period. In doing so, he was saying that they dated from a time before the pre-Roman Celts when the climate was much colder. In 1867 this was all that anyone could say; it meant that the sculpture was 'very old' but had no value in years.

As the number of excavated sites increased it became obvious that the term 'Reindeer Age' was too broad to be useful. Reindeer were not the predominant remains at all sites, and more careful layer-by-layer excavation techniques showed that the range of tools, weapons and artworks present often varied through the thickness of the deposits. By comparing the tools found in the top layer with those found in separate layers down to the oldest at the bottom, it was possible to determine how they varied through time. At La Madeleine in the Dordogne, Lartet and Christy referred to assemblages of tools similar to those found at Montastruc as Magdalenian. This term is still in use and is now known to span the period from about 15,000 to 10,000

years ago. Furthermore, it is possible to say that the artefacts from Montastruc actually belong in the more recent, Middle and Late part of the Magdalenian because of the tool and weapon types present.

Radiocarbon dates for Montastruc

Radiocarbon dating is a method of estimating the age of organic materials by measuring the amount of a radioactive form of carbon, known as carbon 14, it still contains. As radiocarbon decays over time at a known rate, the amount left in a sample indicates its age. It is often assumed that radiocarbon dates tell us precisely how old things are. This is not entirely true. Radiocarbon determinations provide age estimates, which must be carefully considered. A piece of worked antler, dated at the British Museum in 1969, and a barbed antler spear tip have given us two radiocarbon dates for Montastruc but, because of the nature of radiocarbon dating, we cannot take these exactly at face value. The samples gave radiocarbon age estimates of 12070+/-180 years old and 13020+/-130 years old respectively. This means that there is a 95 per cent chance of the first date being between 12,430 and 11,710 years old and the second between 13,280 and 12,760 years old.

The precision of both these determinations is further affected by the fact that these radiocarbon years are not equal to real calendar years, and that the samples on which they are based come from a period when there are dips in radiocarbon uptake caused by atmospheric variations. Although archaeologists usually work with the radiocarbon age, several different methods are now available to allow for the radiocarbon variations and to convert age estimates into real-time values.

Using the latest OxCal 4.1 calibration programme to determine a correct value, the Montastruc age estimates calibrate to 12,693–11,545 BC and 13,911–13,057 BC. As the younger British Museum date was processed over forty years ago, when the method was still in an early phase of development, it is likely that the error of +/-180 is too small and the date is too young. This would suggest that the estimate of at least 13,000 years old in radiocarbon years

may be nearer to 15,000 years old in calendar years, well before the extinction of mammoths, which is estimated at about 13,800 years ago in real years.

To avoid confusion and the necessity of calibrating age estimates made by different laboratories at different times, the dates quoted in this book are given in radiocarbon years before present. As the dated samples do not come from the reindeer sculpture itself, the dates only give an indication of its possible age. Without taking radiocarbon samples directly from the reindeer we cannot be certain of the exact age of the piece and, although only tiny amounts of material are required by modern radiocarbon techniques, drilling into a work of this quality for a sample is out of the question. So, for the time being, we are left to consider the sculpture as being at least 13,000 radiocarbon years old when we look for comparable works of art or try to understand more about the life of the artist.

Western Europe 13,000 years ago
A date of 13,000 years ago falls within the period of the Late Glacial, which followed the Last Glacial Maximum, up to about 10,000 years ago. The term should not conjure up an image of a barren icy landscape. The last time the world's climate became seriously cold was during the Last Glacial Maximum, about 20,000 years ago. Then the cold caused ice sheets to spread down across Scandinavia as far as northern Germany, and huge valley glaciers developed in regions such as the Alps and the Pyrenees. With water that would usually flow from the land down rivers to the sea frozen up, sea levels dropped. The British Isles formed the landlocked north-west peninsula of Europe and the Atlantic and Mediterranean coastlines of France extended far beyond their present outline (see the map on p. 4).

As the climate began to warm up about 18,000 years ago, the ice sheets and glaciers started to melt and gradually shrink. However, the temperature did not continually rise after this; there were times when it reverted back to being colder for periods of up to two thousand years. Nevertheless, by about 15,000 years ago people were able to start returning to the valleys of the Pyrenees, although it is

clear from the animals found at Montastruc that the site was occupied in one of the periods when it was much colder than at present, with conditions like those north of the Arctic Circle today.

To feed the mammoth, saïga antelope, musk ox, reindeer, bison, horse and ibex attested among the animal bones and art at Montastruc, we must imagine a surrounding patchwork of treeless, grassy steppe land with areas of tundra at the time of occupation. Although the reindeer and saïga could exist on low-growing tundra vegetation feeding off lichens and low-growing plants, the other herd animals needed herbs and grasses. The mammoth that returned to Western Europe in much smaller numbers after the Last Glacial Maximum each required 150–200 kilograms (330–440 pounds) of food every day, suggesting rich pastures despite the low temperatures. In sheltered spots, and when it warmed up, birch, willow and pine trees sprang up, but for humans there was little nourishment in this vegetation. Their lives depended on the game, fish and birds that were abundant in the Aveyron valley.

The hunting lifestyle at Montastruc

As at other sites on the north-east side of the Pyrenees, reindeer were the main prey at Montastruc. This animal provided not only food but skins for clothing, bags, blankets, tents or windbreaks, sinew and gut for sewing thread and string, as well as antler and bone for manufacturing equipment. Even the digested stomach contents could be consumed as a vital source of vegetable matter otherwise so difficult to obtain in this environment.

Although a modern study is wanting, evidence from the animal remains noted at Montastruc in the 1950s by Bétirac, as well as the perforated incisor teeth of young reindeer found by Peccadeau de l'Isle, suggest that the site was occupied in summer, perhaps by a group consisting of several families. This was a busy time of year, when it was essential to make and mend all kinds of equipment ahead of the harsh winters. The abundance of needles and needle-making equipment (Fig. 27) indicate that this, and perhaps making clothes, was an important summer task. Reindeer

skins have excellent thermal properties unrivalled even by modern fabrics. When a reindeer gets up from resting in the snow, the snow underneath has not melted because the structure of the hairs creates such good insulation that they prevent any loss of body heat that would cause thawing. Wearing trousers, anoraks, boots and mittens made from reindeer hide could give protection from frostbite and hypothermia to ensure winter survival.

The group moved on from Montastruc in autumn and spent winter camping in the shelter of rock overhangs or caves elsewhere. They probably walked hundreds of miles on their yearly round but we do not know exactly where, although there are possible clues. The reindeer at this time were bigger than modern arctic reindeer and their behaviour is now thought to be different as well. They did not migrate across thousands of miles like modern caribou in northern Canada, but moved much shorter distances to different pastures and mating grounds in the

27 Needles made of bone, found at Montastruc. L. 7 cm (max). British Museum

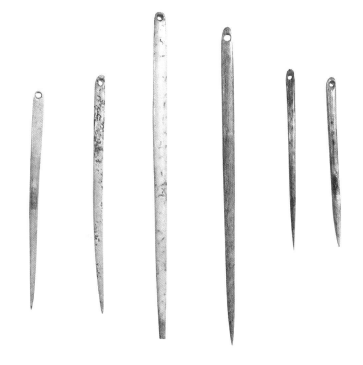

45

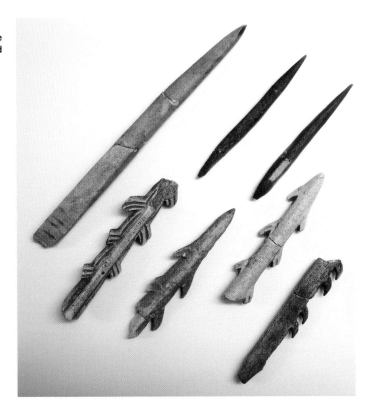

28 Bevel-based and barbed spear tips made of reindeer antler, found at Montastruc. L. 15 cm (max). British Museum

autumn, returning in the spring. Given the similarity of representations and engraving style at sites such as La Vache, where there is evidence of occupation from autumn to spring, it is possible that this movement was to the south. This would also account for the consistency we see in the characteristics of the tools and weapons at Montastruc and other sites in the Aveyron valley with those from sites in the north-east Pyrenees, in the region of the modern town of Foix.

Confirmation of such outreach is confirmed by the presence of seashells perforated and used as jewellery far inland at Montastruc. Whether their annual cycle of movement took them over two hundred miles to the coast or brought them into contact with people closer to the coast with whom they could exchange shells, this still gives some idea of their range.

The hunter's kit

As is typical of the Magdalenian, most of the spear tips found at Montastruc are made of antler rather than flint. The majority have smooth, cylindrical shafts which taper to a point at one end while the other end is thinned by shaving down one or both sides to form a flat bevel, which would fit tightly into the wooden shaft of the spear (Fig. 28). The bevels are often marked with incised diagonal scratches which roughen the surface and create a firm friction grip when inserted into the split end of the shaft. The armoury also includes spear tips with barbs cut on one or both sides of the shaft (Fig. 28), and antler components used to hold tiny flint armatures as barbs. Montastruc has yielded many small flint blades which could have been intended for this purpose.

Spears were launched using hooked spear throwers made of reindeer antler and decorated with carvings of animals. These devices lengthen the thrower's arm, adding power and increasing the speed, force and accuracy of the throw to deadly effect (Fig. 29). The mammoth spear thrower with an upright hook from Montastruc is made from a reindeer antler. The shaft of the antler would have formed the handle and the mammoth was carved from the wider part at the top (see Fig. 3). Originally, the mammoth's tail curled up to form a carved hook, but when this broke the hunter repaired it by making a diagonal slot from the top of the back, down and out between the back legs, and then inserting a shaped piece of antler as a replacement. When this valued weapon broke again across the shaft, it was beyond further repair and had to be thrown away. The spear

29 A spear thrower in use.

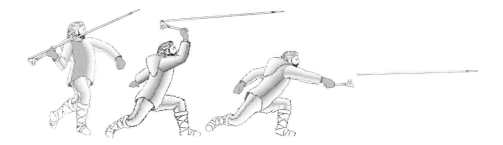

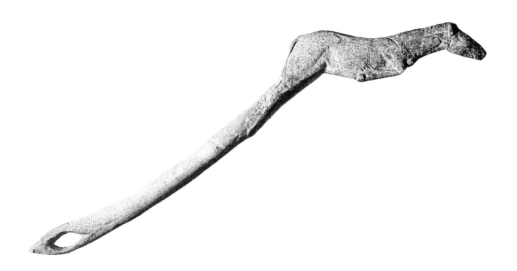

30 Spear thrower carved from reindeer antler in the shape of a leaping horse, found at Montastruc. About 13,000 years old, L. 32 cm. Musée d'histoire naturelle Victor Brun, Montauban, France

thrower in the shape of a horse, found by Bétirac, is another complete example (Fig. 30).

Given the abundance of flint knives, scrapers, saws and burins, as well as the debris left from antler working, it seems that summer at Montastruc was spent making equipment. These tools and weapons, decorated with skilfully carved or engraved figures of animals or carefully delineated patterns, remind us that these hunters were also part of an extraordinary renaissance of art, which started around 15,000 years ago and spread throughout the territory of the Magdalenian, eventually reaching even as far as Britain.

The artistic territory

It was in the earlier part of this period that many of the most famous caves were decorated. As well as the great painted frescoes at Lascaux and Altamira, painted and engraved panels were created in caves much nearer to Montastruc by people who penetrated far underground with the aid of lamps and wood torches fuelled with animal fat. About one hundred miles south of the Aveyron, the justifiably renowned underground sanctuaries Les Trois Frères and Niaux were in use. These sites are called sanctuaries because they were not inhabited but were

probably used for religious purposes. In the great chambers large congregations might have stood, danced or made music in front of the pictures. Elsewhere, small engravings in awkward crevices attest to action and observation by one person at a time.

Within these caves the painted and engraved images had permanence. By contrast, the decoration of tools and weapons lasted only until they broke, and the shallow engravings on stone slabs were only clearly visible while still fresh. In this sense the art of the daylight and everyday life, which was visible to everybody, might have served a related but different purpose. It is in this realm that the Swimming Reindeer belongs, together with numerous other miniature, portable art objects made from bone, antler and ivory made during the Magdalenian, the purpose of which remains to be considered.

Chapter 5
The creative mind

When they were found as two separate pieces in 1866, the Swimming Reindeer were assumed to have had a practical function. Peccadeau de l'Isle described them as decorative dagger handles and, although it was far from clear how they might have been fitted with a flint blade, this purpose was reiterated in several books and essays until the abbé Breuil joined the pair back together in 1905. Reconstructed to its original form, it is now recognized as one of a small number of figurative sculptures that were not made to decorate weapons or as jewellery. As such it is even more difficult to imagine that the reindeer had a mundane function.

The reindeer do not form a strong, usable object. The fragility of the connection between the animals, along with the male's extended back legs, would have prevented its use as a spear thrower or for any other robust purpose, even when new. As they do not appear to decorate a tool or weapon the reindeer may be regarded as a sculpture that, like the drawings incised on stone slabs or drawn and painted on the walls of caves, meets our various definitions of art. Although it is unlikely that such a word existed in the culture of the reindeer hunters, these works certainly represent a system of visual communication that was deeply embedded in their society. Unfortunately, while we can see that they were clearly trying to express the world around them and their lives in it, we are left questioning the significance and meanings of the works.

We can certainly speculate on a whole range of possible meanings for the Swimming Reindeer sculpture. It might have been broken in half and left at Montastruc to end a stretch of bad luck or ward off evil spirits to keep the shelter safe. Making it could have been a way of offering an apology to the reindeer for having to kill some of them. Alternatively, the composition could be an allegory of autumn, made in the hope that the reindeer's mating would be successful, thus ensuring both human and animal

survival in the year ahead. The sculpture could have been a totem for an individual or group, a shaman's wand or the focal point of a story or myth based on a journey in or between the real and supernatural worlds. The deep incisions on the female's flanks may accentuate the colour bars on the coat as wounds, with the trails beneath as blood, to evoke the mastery of the hunter or to bring success.

To us in a rational, modern world some of these speculations may seem banal, and it is impossible to know whether any or none of them are right, but what does seem clear is that the reindeer reflect a religious impulse to be at home in the world at a deeper level. The naturalism of the reindeer carving is evocative of how close the hunters were to nature, while at the same time separated from it by their intelligence. This intelligence is expressed in their ability to symbolize their world in an aesthetically pleasing image through which they might reshape or even transcend it in belief.

Just as the hunter–artists of the Late Glacial created virtual worlds teeming with paintings and drawings of game in the deep subterranean depths of caves, so they carved the reindeer to carry meanings through beauty into the real everyday world. Their modern brains, working like our own, were able to represent meanings beyond words, and still connect with us many millennia later.

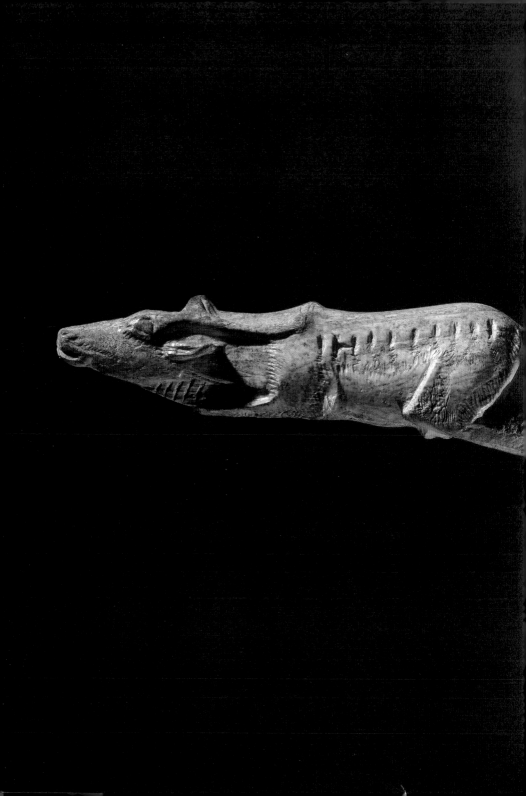

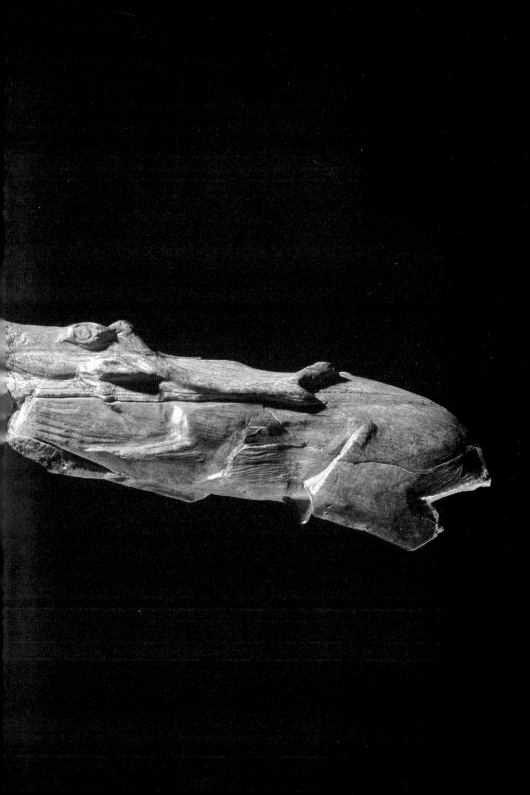

Further reading

This is the first comprehensive account of the Swimming Reindeer. It is based on archival sources, French publications and the author's own research on the object. Sieveking's catalogue cited below is now out of print, but readers interested in finding out more about objects mentioned in this book or discovering other objects in the British Museum's collection can find them by going to http://www.britishmuseum.org/research/search_the_collection_database.aspx and searching by site name or the prefix Palart. For more on Ice Age Art in general, see www.bradshawfoundation.com/sculpture/gallery.php.

The following books offer some further background to the subject:

B.O. Alpert, *The Creative Ice Age Brain*, Santa Fe 2008

J. Clottes, *Cave Art*, London 2008

A. Lister and P. Bahn, *Mammoths. Giants of the Ice Age*, London 2007

A. Sieveking, *A Catalogue of Palaeolithic Art in the British Museum*, London 1987

T. Smith, *The Real Rudolph. A Natural History of the Reindeer*, Stroud 2006

R. White, *Prehistoric Art. The symbolic journey of humankind*, New York 2008

Image credits

Every effort has been made to trace the copyright holders of the images reproduced in this book. All British Museum photographs are © The Trustees of the British Museum.

Map drawn by Stephen Crummy, British Museum
1 Photo: British Museum; P&E Palart.550, Christy Collection
2 L. Figuier, *Primitive Man* (1870)
3 Photo: British Museum; P&E Palart.551, Christy Collection
4 Musée d'Archéologie Nationale, Paris, MAN30361; photo © RMN / Jean-Gilles Berizzi
5 E. Lartet and H. Christy, *Reliquiae Aquitanicae* (1875)
6 Photo: British Museum; P&E Palart.506
7 Photo: British Museum
8 Photo: British Museum
9 *Revue archéologique* (1868)
10 Illustration by Stephen Crummy, British Museum
11 Photo: British Museum
12 Photo: British Museum
13 British Museum; P&E Palart.584 and 589
14 Photo: British Museum
15 Musée d'Archéologie Nationale, Paris, 83,356; drawing by S. Rougane in J. Clottes and H. Delporte, *La Grotte de la Vache* (2002)

16 © B&C Alexander / ArcticPhoto
17 Drawing by P. Laurent in R. Avambourou, *Le Gisement Préhistorique de Duruthy* (1978)
18 Drawing by P. Laurent in R. Avambourou, *Le Gisement Préhistorique de Duruthy* (1978)
19 Illustration by Stephen Crummy, British Museum
20 Illustration by Stephen Crummy, British Museum
21 British Museum, Department of Conservation and Scientific Research
22 Photos: author
23 © B&C Alexander / ArcticPhoto
22 Photos: author
25 Musée d'Archéologie Nationale, Paris, MAN55351; photo © RMN / Loïc Hamon
26 Photo: author
27 British Museum, Christy Collection; photo: author
28 British Museum, Christy Collection; photo: author
29 Illustration by Stephen Crummy, British Museum
30 Musée d'histoire naturelle Victor Brun, Montauban; P. Graziosi, *Palaeolithic Art* (1960), pl. 38
31 Photo: British Museum